9.99

KU-053-510

BEAUTY
IN
PHOTOGRAPHY

C26926

C26926
770·1 ADA
3 WKS

ROBERT ADAMS

BEAUTY
IN
PHOTOGRAPHY

ESSAYS
IN
DEFENSE
OF
TRADITIONAL
VALUES

THE LEARNING CENTRE
CITY & ISLINGTON COLLEGE
444 CAMDEN ROAD
LONDON N7 0SP
TEL: 020 7700 8642

APERTURE

For William Main

CONTENTS

Preface

PARTS OF THE BOOK were begun over twenty-five years ago, at a time when it seemed to me photography students weren't asking the questions they really wanted to ask—the risky ones, the variants on "What's worth a life?" Readers have occasionally sensed an ambivalence in my own response to that question, and I can only say that I hope I was honest enough to show it. A character in Eudora Welty's *The Golden Apples* thinks that "all the opposites on earth [are] close together," and "of them all, hope and despair [are] the closest blood." That is, it seems to me, what each of us experiences.

At one point in the title essay I refer to beliefs beyond the scope of the essay, beliefs that justify some of what I go on to write. I have wondered if I should have tried harder to be forthcoming about those convictions, but I still find it difficult to describe them without making them unrecognizable to myself. Perhaps it is enough to say that T. S. Eliot's *Four Quartets* describe many of them for me.

When readers learn that I was a teacher, and then encounter references to literature and art, past and present, they ask whether I think an appreciation of art requires formal education. I do not. The essay with the

most citations, the title essay, originated in 1976 as a talk to students at St. John's College in Santa Fe, where the focus is a core of "great books"; I felt free there to rely on their understanding of the importance of tradition. No one, though, has to go to college to make or understand or enjoy art. Wonderful artists and critics—some of the best—have educated themselves.

Among the biggest shifts in photography since the book was written has been a move away from black and white to color. Because there are no examples of color in the book, or mention of its use, readers have wondered whether I find it unimportant. To the contrary, any method by which form can be effectively recorded and meaning affirmed seems to me important, and were I to write the book over I would try to include successful examples. If, as a personal matter, I have chosen not to make color pictures, it is because I have remembered how hard it is to write good free verse, with which color photography has some similarities, both being close to what occurs naturally.

Another change in photography has been the arrival of computer manipulated imagery, allowing easier pictorial invention. I still believe mainly in the opportunities afforded by acceptance, but invention is no longer, as I wrote, "so laborious as to be in most instances perverse," and I suspect that there will be those who will learn to put the new technology to respectful use.

Where the book has spoken to people it is, I think, largely because the subject of the essays—art—is more substantial than is generally allowed in the press. We know from experience that the pictures we treasure, the ones that sustain us, are independent of fashion. Sometimes it helps to be reminded, for courage.

Robert Adams
Longmont, Colorado, 1996

Foreword

TOPICS in the essays overlap, and my treatment of them is brief, personal, and unscholarly. Though some of the essays were first given as academic lectures, my hosts forgave me my method on the ground that I had been asked to speak as a photographer. That I forced them to this indulgence was, I now suspect, a way for me to see if we shared an unfashionable assumption—that art and its practice are of a piece with life.

TRUTH AND LANDSCAPE

WHEN travelers reach the foothills west of Denver, they often stop to be photographed against the Great Plains or the Continental Divide. They remind us, as they smile and look into the distance, of the fondness Americans traditionally have shown for their geography.

There is evidence, however, that the affection may be ending. Along the Front Range, for example, buildings are now often being designed to allow few views of the outdoors. We are told that this protects office furnishings from the sun, adds retail display space, and makes possible uniform lighting; customer and worker morale is, it is reported, unharmed. Apparently business has discovered the dark side of ecological awareness, managing, as Camus said of those who built the city of Oran, to "exorcize the landscape."

Admittedly scenic grandeur is today sometimes painful. The beautiful places to which we journey for inspiration surprise us by the melancholy they can induce. On northern Long Island recently, for instance, at the end of a promontory where I was living — an overlook from which one could see ducks and wild swans and miles of gleaming bay — were scattered hundreds of empty liquor bottles, a common record of sorrow in places worthy of postcards.

Our discouragement in the presence of beauty results, surely, from the way we have damaged the country, from what appears to be our inability now to stop, and from the fact that few of us can any longer hope to own a piece of undisturbed land. Which is to say that what bothers us about primordial beauty is that it is no longer characteristic. Unspoiled places sadden us because they are, in an important sense, no longer true. Thomas Gray's consolation — "many a flower is born to blush unseen, and waste its sweetness on the desert air" — has become an irony; we have the flowers counted and fenced.

Part of the anodyne offered by Denver builders has been to disallow windows, but another part has frequently been to substitute paintings of uniformly attractive, often foreign, landscapes. The views are unconvincing, but they address a need that is human, and as a landscape photographer I find myself asking whether pictures based on other principles could do better. Given our geography — the actual, mixed one of great trees and of fields littered with Styrofoam, of still-awesome mountains and of valleys dense with tract houses — is it possible for art to be more than lies?

Landscape pictures can offer us, I think, three verities — geography, autobiography, and metaphor. Geography is, if taken alone, sometimes boring, autobiography is frequently trivial, and metaphor can be dubious. But taken together, as in the best work of people like Alfred Stieglitz and Edward Weston, the three kinds of information strengthen each other and reinforce what we all work to keep intact — an affection for life.

We expect first from landscape art, as the name implies, a record of place. With the help of the camera we can recognize and enjoy an unnamed New Mexican mesa or the Delaware Water Gap. Although we are not as naïve as we once were about the accuracy of the pictures, we continue to value them initially as reminders of what is out there, of

what is distinct from us. There is a certainty in geography that is a relief from the shadow world of romantic egoism.

If landscape art were only reportage, however, it would amount to an ingredient for science, which it is not. There is always a subjective aspect in landscape art, something in the picture that tells us as much about who is behind the camera as about what is in front of it. Pictures are never so cleanly tautological as, say, Gertrude Stein's description of a rose. For one thing the subject is too big; a normal lens, though it can cover a rose, can never cover a whole landscape, just as when without a camera we stand in the middle of a field and after turning full circle must decide what part of the horizon to face.

That a photograph is unlikely to be a laboratory record is evident when we think about how it is made. Most photographers are people of intense enthusiasms whose work involves many choices — to brake the car, grab the yellow instead of the green filter, wait out the cloud, and, at the second everything looks inexplicably right, to release the shutter. Behind these decisions stands the photographer's individual framework of recollections and meditations about the way he perceived that place or places like it before. Without such a background there would be no knowing whether the scene on the ground glass was characteristic of the geography and of his experience of it and intuition about it — in short, whether it was true.

Making photographs has to be, then, a personal matter; when it is not, the results are not persuasive. Only the artist's presence in the work can convince us that its affirmation resulted from and has been tested by human experience. Without the photographer in the photograph the view is no more compelling than the product of some anonymous record camera, a machine perhaps capable of happy accident but not of response to form.

Art asserts that nothing is banal, which is to say that a

serious landscape picture is metaphor. If a view of geography does not imply something more enduring than a specific piece of terrain, then the picture will hold us only briefly; we will probably prefer the place itself, which we can smell and feel and hear as well as see — though we are also likely to come away from the actual scene hoping somewhere to find it in art. This is because geography by itself is difficult to value accurately — what we hope for from the artist is help in discovering the significance of a place. In this sense we would in most respects choose thirty minutes with Edward Hopper's painting *Sunday Morning* to thirty minutes on the street that was his subject; with Hopper's vision we see more. Precisely what it is that he helps us to see must be carefully talked around, but the painter Robert Henri came close to it in his description of the discovery to be made with the help of all successful paintings; in such pictures, he observed, "There seem to be moments of revelation when we see the transition of one part to another, the unification of the whole. There is a sense of comprehension."

We rely, I think, on landscape photography to make intelligible to us what we already know. It is the fitness of a landscape to one's experience of life's condition and possibilities that finally makes a scene important or not. Weston's photograph from 1945, for example, of a pelican floating dead in kelp and lumber (Plate I), is to me, as it is to many, unforgettable because it is true. It records accurately a mystery at the end of every terror — the survival of Form.

Not surprisingly, many photographers have loved gardens, those places that Leonard Woolf once described as "the last refuge of disillusion." Gardens are in fact strikingly like landscape pictures, sanctuaries not from but of truth. An etymological detail that Kenneth Clark raises in his discussion of landscape — *paradise* is the Persian word meaning "a walled enclosure" — stands I think as perhaps the best possible synopsis of what a photographer sees through the

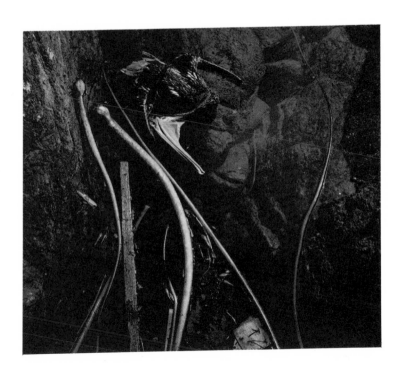

1 Edward Weston, *Tidepool*, 1945

finder of his camera just before he releases the shutter. His view is of a safe wayside for travelers, built from the local geography, but still and clarifying.

Dag Hammarskjöld, Secretary-General of the United Nations from 1953 until his death in 1961, was at the time he died preparing to retire to a farm on the southern coast of Sweden. The house, a part of which is now open to the public, is a one-story building of timber and stucco that, like many Scandinavian farm buildings, encloses a courtyard. In July 1968, when I visited, the flagstones were warm in the sun, hollyhocks bloomed against one wall, and the smell was of the ocean and newly cut hay.

Two rooms in the house contain Hammarskjöld's personal effects, including his collection of painting and sculpture. The variety is striking — pictures of the Swedish countryside by regional artists are placed among works by Picasso, Georges Braque, and Barbara Hepworth. It is, I learned, an installation designed by friends to accord with his conviction that if one loved one's own landscape it would then, and only then, be possible to love other landscapes.

Hammarskjöld was, it pleases me, an avid photographer. Many wire photos showed him, while visiting Asian and African countries for the United Nations, smiling and looking down through his Hasselblad. Once, when he was on a diplomatic mission to India, in fact, his hosts noted his enthusiastic picture taking and offered to fly him along the side of Everest (he was also a mountain climber). Though the plane was an unpressurized DC3, he made effective use of the opportunity, and in the resulting pictures there are elements of geography, autobiography, and metaphor.

The final entry in Hammarskjöld's notebooks is a poem that reflects the condition and hope of us all, but especially the condition and hope of landscape photographers. In it he

tells of the burden of sight in the modern, disfigured world, he describes memories of a better geography, and he comes to a discovery. The poem, "August 24, 1961," begins with a description of waking in the city, an experience of dislocation and potential dread:

> Is it a new country
> In another world of reality
> Than Day's?
> Or did I live there
> Before Day was?
> I awoke
> To an ordinary morning with gray light
> Reflected from the street.

Faced with that gray, Hammarskjöld tries, as we all often do, to escape into memories of a better place, which for him was Lapland:

> But (I) remembered
> The dark-blue night
> Above the tree line,
> The open moor in moonlight,
> The crest in shadow.
> Remembered other dreams
> Of the same mountain country:
> Twice I stood on its summits,
> I stayed by its remotest lake,
> And followed the river
> Towards its source.

Then, as Hammarskjöld recalls coming to the origin of the river, he is brought to a recognition. His memory of the way the lake or ice field looked — presumably it was a landscape in glacial, alpine grays — brings him back to the gray street in front of him:

> The seasons have changed
> And the light
> And the weather

And the hour.
But it is the same land.
And I begin to know the map
And to get my bearings.

Judged by the achievement of Hammarskjöld's life, the insight was an enabling one. And it was, I think, strengthened by his fondness for landscape art, the main business of which is a rediscovery and revaluation of where we find ourselves.

BEAUTY IN PHOTOGRAPHY

THE POET William Bronk states succinctly what most poets believe: "Ideas are always wrong." This conviction helps account for the uneasy place of artists in the academy, the home of ideas. William Carlos Williams formulated the only resolution that is fully acceptable from an artist's point of view: "No ideas but in things." Generalizations are impermissible unless they emerge before our eyes from specifics, from concrete evidence, from things.

A tendency to violate Williams's rule is what for artists makes an enemy of philosophy; philosophy can forsake too easily the details of experience. Aesthetics is a distrusted discipline in the studio because it seems inevitably to lead away from the works of art produced there. Relatedly, the discipline of aesthetics seems to artists to inhibit creation; many writers and painters have demonstrated that thinking long about what art is or ought to be ruins the power to write or paint. There are, for example, the notorious instances of Tolstoy denouncing, on the basis of high-sounding principles, his own novels, not to mention Shakespeare's plays, and of Coleridge becoming so fascinated by abstractions that it was increasingly impossible for him to write poetry.

We all have to risk thinking, however, if our efforts are to

have any shape at all, and like others in the arts I find myself thinking about the word *Beauty*. What follows is an attempt to define it as it applies to photography.

At the outset, though, I need to raise a warning: my position is based on some beliefs that I would not for a moment try to debate, not because they are irrational but because they are unprovable. The job of the photographer, in my view, is not to catalogue indisputable fact but to try to be coherent about intuition and hope. This is not to say that he is unconcerned with the truth.

Aesthetics is usually defined as "a branch of philosophy dealing with the nature of the beautiful and with judgments concerning beauty." I recall the endurance it took when I was a student to complete an aesthetics course based on that definition. *Beauty* seemed to me then an obsolete word, appropriate to urns and the dead inside them; what had the term to do with the realities of this century?

I have since learned, however, that the word *beauty* is in practice unavoidable. Its very centrality accounts, in fact, for my decision to photograph. There appeared a quality — *Beauty* seemed the only appropriate word for it — in certain photographs and paintings that opened my eyes, and I was compelled to learn to live with the vocabulary of this new sight, though for many years I still found it embarrassing to use the word *Beauty*, even while believing in it.

If the proper goal of art is, as I now believe, Beauty, the Beauty that concerns me is that of Form. Beauty is, in my view, a synonym for the coherence and structure underlying life (not for nothing does Aristotle list plot first in his enumeration of the components of tragedy, a genre of literature that, at least in its classical form, affirms order in life). Beauty is the overriding demonstration of pattern that one observes, for example, in the plays of Sophocles and

Shakespeare, the fiction of Joyce, the films of Ozu, the paintings of Cézanne and Matisse and Hopper, and the photographs of Timothy O'Sullivan, Alfred Stieglitz, Edward Weston, and Dorothea Lange.

Why is Form beautiful? Because, I think, it helps us meet our worst fear, the suspicion that life may be chaos and that therefore our suffering is without meaning. James Dickey was right when he asked rhetorically, "What is Heaven, anyway, but the power of dwelling among objects and actions of consequence." "Objects of consequence" cannot be created by man alone, nor can "actions of consequence" happen in a void; they can only be found within a framework that is larger than we are, an encompassing totality invulnerable to our worst behavior and most corrosive anxieties.

Art's beauty does not lead, of course, to narrow doctrine. The Form it affirms is not neatly finished, at least to our eyes. It does not lead directly to a theology or a system of ethics (though it reminds me of the wisdom of humility and generosity). William Carlos Williams said that poets write for a single reason — to give witness to *splendor* (a word also used by Thomas Aquinas in defining the beautiful). It is a useful word, especially for a photographer, because it implies light — light of overwhelming intensity. The Form toward which art points is of an incontrovertible brilliance, but it is also far too intense to examine directly. We are compelled to understand Form by its fragmentary reflection in the daily objects around us; art will never fully define light.

How, more specifically, does art reveal Beauty, or Form? Like philosophy it abstracts. Art simplifies. It is never exactly equal to life. In the visual arts, this careful sorting out in favor of order is called composition, and most artists know its primacy. An assistant of Ozu's remembers, for example, that during the making of the film *Late Autumn*

there was this table with beer bottles and some dishes and an ashtray on it, and we had shot the scene from one side and were going to shoot it from the other side, when Ozu came up and began shifting the objects around. I was so shocked that I said that if he did that he would create a bad break in continuity, that everyone would notice that the beer bottles were not on the right and the ashtray on the left. He stopped, looked at me, and said: "Continuity? Oh, that. No, you're wrong. People never notice things like that — and this way it makes a much better composition." And he was right, of course. People don't. When I saw the rushes I didn't notice anything wrong with those scenes.

Art takes liberties, then, to reveal shape.

As we have observed, however, the abstractions of art are different from those of philosophy in being constructed of specifics, concrete examples that are believable as individual facts, or strongly seem so. (Aristotle pointed out that the strength these specifics add is that usually we can test them by our own experience, in terms of probability.) Photography, more than any other art, is tied to this use of specifics. With a camera, one has to love individual cases. A photographer can describe a better world only by better seeing the world as it is in front of him. Invention in photography is so laborious as to be in most instances perverse. Edward Weston wrote in his daybooks that he started to photograph as a result of his "amazement at subject matter"; I doubt that any great photographer ever starts because of amazement over his camera or over a particular photographic process. He has to love these, too, but it is not with them that his fundamental dedication as an artist begins. The name of the group to which Weston briefly belonged, "f64," captures well this primary commitment to things (f64 is the smallest

aperture available on most view camera lenses; by its use the depth of focus is maximized, and the most precise possible rendering of detail is achieved).

If the goal of art is Beauty and if we assume that the goal is sometimes reached, even if always imperfectly, how do we judge art? Basically, I think, by whether it reveals to us important Form that we ourselves have experienced but to which we have not paid adequate attention. Successful art *re*discovers Beauty for us.

One standard, then, for the evaluation of art is the degree to which it gives us a fresh intimation of Form. For a picture to be beautiful it does not have to be shocking, but it must in some significant respect be unlike what has preceded it (this is why an artist cannot afford to be ignorant of the tradition within his medium). If the dead end of the romantic vision is incoherence, the failure of classicism, which is the outlook I am defending, is the cliché, the ten thousandth camera-club imitation of a picture by Ansel Adams.

The beauty of a work of art can also be judged by its scope. The greatest beauty tends to encompass most; the artworks of largest importance frequently have within them the widest diversity. A. R. Ammons phrased this well in the poem *Sphere*, in which he observed that "the shapes nearest shapelessness awe us most, suggest the god." This is so, I think, because most of life seems shapeless most of the time, and the art that squares with this powerful impression seems most convincingly to confront disagreeable fact. Thus, for example, while Charles Sheeler's photograph of an ore car at the Ford River Rouge plant is unquestionably beautiful, its beauty is of a lesser sort than that found in some of the formally rougher but more complexly human photographs by Henri Cartier-Bresson.

There are, of course, wonderful exceptions to this rule,

though they are perhaps more apparent exceptions than real ones. Bell peppers would seem to be about as limited as any subject matter could be, but in fact how unlimited they are when photographed by Weston.

Finally, I think the success of a work of art can be measured not only by its freshness and the diversity of the elements it reconciles, but also by the apparent ease of its execution. An artwork should not appear to have been hard work. I emphasize "appear" because certainly no artwork is easy to make; Mu Ch'i's renowned ink drawing *The Six Persimmons* (Plate II) may have been completed in seconds, but the study and control beneath its freedom are known to anyone who has tried something similar; hundreds, maybe thousands, of attempted persimmons preceded those faultless six.

Mu Ch'i's picture is unforgettable, nonetheless, at least in part, because it looks as if it had been effortlessly done. The same is true of photographs; they seem to validate the self-effacing observation of the combat photographer Kyoichi Sawada: "If you're there, you get good photographs." The pictures Sawada made convince us of this; had we been in Vietnam, we too could have taken the pictures he did, the ones that brought him a Pulitzer Prize. Stated another way, luck seems to be a large part of good picture making, and not just in combat photography. If we had been at the old church that evening in Hernandez as the moon came up, we could surely have gotten a picture at least something like the one Ansel Adams made. Or so, in the presence of that and other fine pictures, we are deceived to think.

To remind ourselves of the significance of grace in photography — of the importance of seeming to do the job easily — we need only to examine a copy of a mass-circulation photography magazine. Most of the pictures

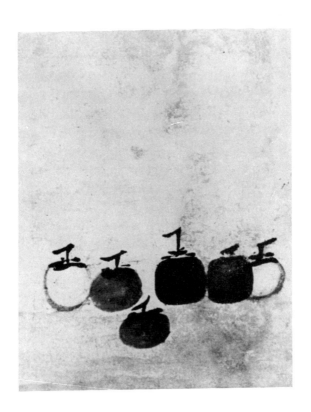

II Mu-Ch'i (active 1200-1250), *The Six Persimmons* (ink on paper)

suggest embarrassing strain: odd angles, extreme lenses, and eccentric darkroom techniques reveal a struggle to substitute shock and technology for sight. How many photographers of importance, after all, have relied on long telephoto lenses? Instead their work is usually marked by an economy of means, an apparently everyday sort of relationship with their subject matter.

Why do most great pictures look uncontrived? Why do photographers bother with the deception, especially since it so often requires the hardest work of all? The answer is, I think, that the deception is necessary if the goal of art is to be reached: only pictures that look as if they had been easily made can convincingly suggest that Beauty is commonplace.

Before going on with this exploration of Beauty in photography I would like to pause, in anticipation of objection, to consider whether such a definition of Beauty does not rule out most twentieth-century painting and sculpture. If so, how parochial can we photographers be?

The Form I have equated with Beauty — that is, the order in art that mirrors the order in the Creation itself — has not, plainly, been as consistently the subject of the art of this century as it was, for example, during the Middle Ages. Some of what in our time we have called art has been concerned solely and finally, I believe, with perceptual form, that is, form completely free of any conceptual content, form purely of ordered sensation; the pleasures we associate with it are exclusively those of color and shape and texture. Setting aside the artists' intent, works by Josef Albers, Jackson Pollock, and Frank Stella are conspicuous examples. Insofar as art has occupied itself in this fashion, it seems to offer real but minor pleasures, the joys of decoration. All ages have rightly valued decoration — it is not exclusively our obses-

sion — and in moderation it does not imply decadence. Moderation, though, is the test that seems to undo us.

We must be careful, nonetheless, with what we categorize as solely decorative. Some twentieth-century art seems at first to offer only perceptual rewards, but later reveals a rich ambiguity. Sculptor David Smith's Cubi and Zig series (Plate VIII), for example, do imply, by ways I cannot explain, the splendor of which William Carlos Williams spoke; these great works of abstract sculpture are more than pleasant, deeper than the entertaining patterns of accident or play.

In short, a revelation of Beauty/Form is as open to painting and sculpture as it is to photography. This is so because a successful reflection of Form is not necessarily antithetical to the tendency of painting and sculpture to a greater degree of abstraction. Extreme literalness is not essential; Andrew Wyeth's realism often points nowhere, in my experience, but Arthur Dove's abstract landscapes suggest a great deal. The painters who have been most successful do seem to occupy a middle ground, though that can range from Edward Hopper's representational paintings and the semirepresentational work of Georgia O'Keeffe and Milton Avery to the nearly total abstractions of Ellsworth Kelly.

To return to photography, the large number of memorable pictures in photography's century and a half of history raises an issue. Are all important pictures beautiful? For instance, there is Robert Capa's photograph of a Spanish loyalist, fatally wounded a moment earlier, falling to the side of the 35-mm. frame (Plate V). It is as vivid a synopsis of violent death as has been produced in our century. But is it beautiful?

Someone might conceivably argue that in purely perceptual terms, judged solely as a composition, the photograph is a pleasing assemblage of shapes. To defend the picture on

these grounds alone, however, is a distortion; it is to deny the overwhelming, primary importance of the subject matter. The point is that the falling object is a man.

What Capa's photograph shows is a truth — a common, terrible, and therefore important truth. But again, does this mean the picture is beautiful? Is Truth Beauty and vice versa? The answer, as Keats knew, depends on the truth about which we are talking. For a truth to be beautiful, it must be complete, the full and final Truth. And that, in turn, leads me to a definition of Beauty linked unavoidably to belief. For me, the truth of Capa's picture is limited; it deserves, therefore, some lesser adjective than "beautiful," some word suggesting the partial truths occasionally recorded by heroic journalists.

Significant photographs are not then necessarily beautiful. There are many important pictures that do not contain the full Truth, that do not reveal Form, that do not show us coherence in its deepest sense. Examples, ones that are nonetheless among the most powerful pictures I know, include Daido Moriyama's *Stray Dog* (which about does it for dog pictures) (Plate IV), Jacob Riis's terrifying view of a blind beggar and the world in which he must survive (Plate VI), and Diane Arbus's portrait of a sword swallower (Plate VII).

As these photographs begin to suggest, it is even possible for a picture to be strongly, classically composed and still not convey the final truths that are crucial to Form and thus to Beauty. Often, however, composition *is* a major way for a photographer to show the wholeness of life; the structure of an entire picture can suggest the Form that is Beauty. Such photographs bring to mind Matisse's remarks about the word "expression":

> Expression, for me, does not reside in passions glowing in a human face or manifested by violent movement. The entire arrangement of my picture is

expressive: the place occupied by the figures, the empty spaces around them, the proportions, everything has its share.

Milton Avery's wife offered a telling description of her husband's work: "The object of the painting was a series of relationships of form and color in which nature was the binding force. Milton's interest was in order, like the high order in nature in which everything worked." I would include among the photographs in which everything works Alfred Stieglitz's *Evening, New York from the Shelton* (Plate III), Nick Nixon's portrait of his wife and her sisters in 1975 (Plate IX), and Timothy H. O'Sullivan's *Soda Lake* (Plate XIV).

Though I have just stressed the formal qualities of these pictures, their beauty is not, to repeat, solely a matter of related shapes. Beauty is, at least in part, always tied to subject matter. A photographer can even reflect Form and at the same time pay relatively less attention to composition than did the photographers responsible for the preceding examples. It is possible to reveal Beauty simply by calling the viewer's attention to a human face, as Edward Curtis did in his portrait of Chief Joseph (Plate X), or by showing relationships among people, as Ben Shahn did in his picture of men discussing politics (Plate XI), or even by just pointing out objects with which we live or by which we express ourselves, as Dorothea Lange did in her record of a sign by the air pump in a small gas station (Plate XII). In these subjects there is incontrovertible evidence of Form, and the function that composition serves is subordinate, though essential, to focus our attention on the subject.

Though I have been trying to define *Beauty* so that the word can be of some use, I also believe that certain pictures, very great ones, are too large for categories, too grand for yes or no. Is Lange's *Migrant Mother* an instance of defeat or of determination? Is Shahn's *Strawberry Picker's Child* (Plate

XIII) a case of pointless social waste, or is she holy? Perhaps because in these pictures a sense of possibility is so precariously but tenaciously held, I find them beautiful, sometimes the most beautiful of all.

I want to raise another question about Beauty, a question mature persons can perhaps answer easily, but one that troubled me when I was young: if Beauty and art are as I have described them, are they by themselves enough? Is art a sufficient consolation for life? Can Beauty make suffering tolerable?

The fact is, I think, that they are only partly sufficient. If we are not too burdened by disappointment or loneliness or pain, there are certainly times when art can help; there are moments when great pictures can heal. Views by Masaccio and Rembrandt and Cézanne and Stieglitz, among others, have all been important to me in this way.

On some occasions, however, Beauty, whether in nature or mirrored in art, can itself be painful. I have walked in the mountains on clear winter afternoons when the landscape I discovered in the camera's finder was, in its spectacular independence of us, frightening; I have also come on city tract houses so inhumanly beautiful that they had over them the chill of empty space. It would be misleading not to acknowledge that on certain of these occasions I have had to pack my camera and leave. Sometimes it has been enough to search out a cafe blessed with a jukebox, rattling dishes, and human voices. Family and friends are better though. What a relief there is in an anecdote, a jumping dog, or the brush of a hand. All these things are disorderly, but no plan for survival stands a chance without them.

In conclusion, I would like to turn to a current issue. If photography can reveal to us not only Truth but Beauty, it is

certainly unnecessary to explain further an affection for it; nonetheless, one may speculate about the suddenly widespread interest in it. Photography has, after all, been with us now a long while, and until recently those who thought of it as an art were a small minority.

Fashion and commerce surely account for some of the sudden change; buy this or that camera, invest in this or that print. Related to these considerations but more serious is the fact that painting has temporarily forsaken its historic concerns, allowing photography to take them up (there is no reason painting cannot circle back to its previous position of importance, assuming painters and dealers rid themselves of their mania for showy novelty in technique). Photography's abrupt rise also has to do, I suspect, with our distrust of language; the true outlines of wars and other barbarities have recently been obscured to an unusual degree by talk; maybe, we hope, we can find the Truth by just looking.

Among additional and perhaps related reasons for our increased attention to photography is the withering away of literary possibilities. Drama and fiction used to be prime reflections of Form, of structure in events. They told a story, and the story, if we believed it (if we thought it probable), reminded us of an often painful but nonetheless reassuring order in life. Now, sadly, only certain kinds of stories seem to match our experience; they are to our distress the stories that deny any redemptive pattern. Experience seems to validate stories with unearned, arbitrary endings, ones like automobile accidents and disease. The only other stories we find ourselves able to accept are ones about events so routine and therefore undeniably probable that they are also banal. But to what Beauty does the absurdity of death by car accident testify, and to what splendor does banality point? There have been solutions to these questions, and they have made important reading (one thinks of Camus

and Joyce), but they have not proved to be solutions on which a great many interesting variations can be based.

Theodore Roethke wrote in his notebooks, "I wish I could find an event that meant as much as simple seeing." Had he been able he might have become a dramatist or a novelist. Because he could not discover such an event, he became a poet, a describer of things, a recorder of Form independent of stories, an ally of the photographer Alfred Stieglitz, who observed that "Beauty is the universal seen."

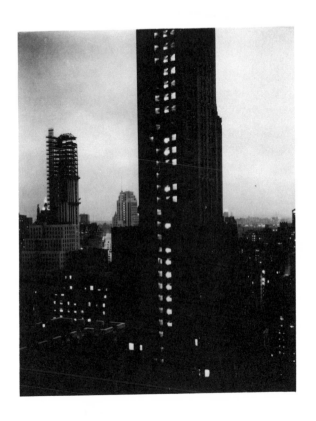

III Alfred Stieglitz, *Evening, New York from the Shelton*, 1931

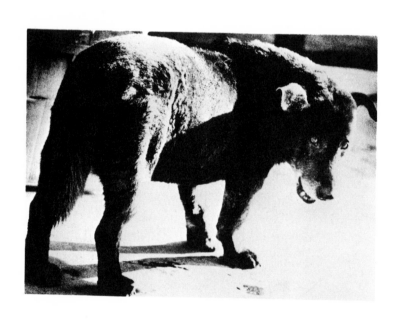

IV Daido Moriyama, *Stray Dog*, 1971

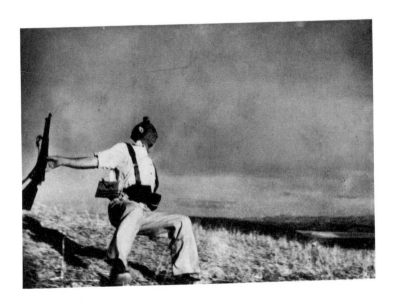

V Robert Capa, *Spain*, 1936

VI Jacob Riis, *Blind Beggar*, 1888

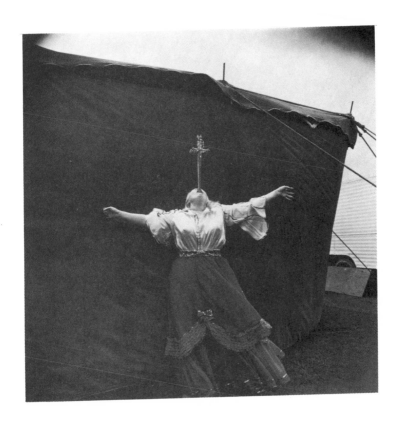

VII Diane Arbus, *Albino Sword Swallower at a Carnival, Maryland*, 1970

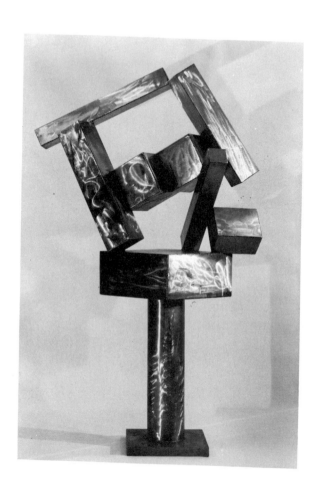

VIII David Smith, *Cubi* XVII, 1963 (stainless steel)

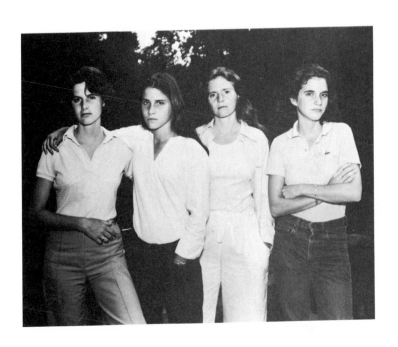

IX Nicholas Nixon, *Heather Brown McCann, Mimi Brown, Bebe Brown Nixon, and Laurie Brown, New Canaan, Connecticut,* 1975

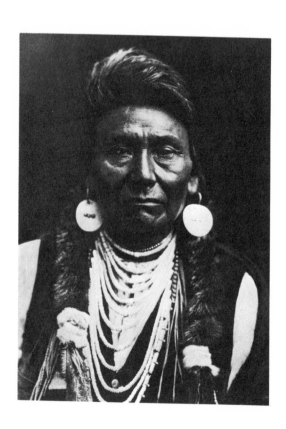

X Edward S. Curtis, *Chief Joseph of the Nez Percé*, 1903 (photogravure)

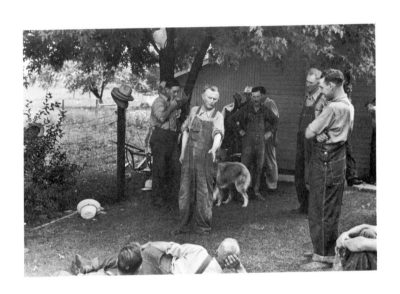

XI Ben Shahn, *Talking Politics before Dinner at Wheat-harvest Time*:
Central Ohio, 1938

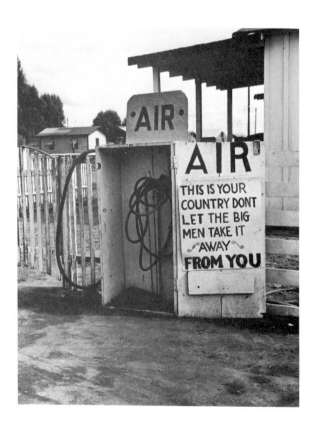

XII Dorothea Lange, *Kern County, California,* 1938

XIII Ben Shahn, *Strawberry Pickers' Child; Louisiana*, 1935

XIV Timothy H. O'Sullivan, *Soda Lake, Carson Desert*, 1867

CIVILIZING CRITICISM

IN 1886 A group of painters, among them remarkable men like Degas, Pissarro, and Seurat, arranged to hold an exhibition in Paris. On opening day the crowd was for the most part hostile. Paul Signac, another participant, afterward described one visitor whose ways were characteristic; the man apparently spent the day running between the exhibition hall and a nearby cafe, enlisting everyone he could to come and join his ridicule. He was so anxious, in fact, to get in with his new recruits that he would impatiently toss his entry fee at the turnstile attendant and not even wait for the change.

The incident is recounted by John Rewald in his History of Impressionism, a disturbing book that catalogues the vilification to which the Impressionists were subjected. Rewald's conclusion is bleak: "The only thing to be learned from the critics was how to suffer the sting of their attacks and carry on just the same, accomplishing a task which more than any other required serenity." It is a summation that unfortunately has relevance today, though less for painters than photographers. How many newspaper reviews of photographic shows currently seem written in a bitter need for vengeance (though in retaliation for what offense it is frequently hard to say; the reviews make me want to see the pictures).

I was lucky. I began to photograph in the last years of the medium's neglect, before anyone thought to envy a photographer. It must be sobering to be a novice in the present climate — and not just because of the reviewers; the prevailing stance among most photographers and museum people is of guarded professionalism.

There are reasons, of course, for the loss of a sense of community among photographers. For one thing, there are too many of us, and, as we go without work, the numbers who teach photography rise, and then they go unemployed too. The money problem sours a lot. Not long ago I discovered that it would be possible for me to earn an adequate living by lecturing about photography; at the same time I knew that it remained impossible to survive by photographing, by doing what I was to lecture about. Irony of this sort does not sweeten life.

The rancor that one finds now in discussions of photography is complex in origin. In part the ill will can be traced to the fact that photographic criticism is currently mostly the province of the young, some of whom have not yet often enough made fools of themselves to be cautious or suffered enough to be charitable. And there is the frustrating nature of the medium itself: it is harder in photography than in painting to establish a recognizable style; this leads to desperate efforts to establish a style at any cost and in turn to the creation of technically accomplished but otherwise empty pictures that anger those who must write about them.

Reasons for bad behavior do not, however, excuse it. We are often left on the one hand with uncivil and unjust criticism, and on the other with the pictures, and with what we learn from photographers about their creation. What disturbs me is the unrelatedness of much critical rhetoric, which is frequently savage, to the experience of the artist. David Smith, the sculptor, wrote in bewilderment in his

journal, "Does the onlooker realize the amount of affection which goes into a work of art — the intense affection ... and total conviction?" What the artist attempts to do is to make something that will convince us of life's value. It is an effort on our behalf that requires considerable risk and sacrifice, and it is open to question whether some critics understand this when they attack.

Camus once observed that "the only people who can help the artist in his obstinate quest are those who love him, and those who, themselves lovers or creators, find in their own passion the measure of all passion, and hence know how to criticize." My assumption is that we as viewers and thus as critics *do* want to help artists. If a critic's proper function is to cull away failed art, it must also be to nourish successful art. But how is this done? What kinds of critical responses to photographs are useful, what kinds promote the creation of more and better pictures?

To begin with, if I were to choose a model of the critical response that seems to be in short supply, I would point, at the risk of seeming an evangelical preacher or just a sentimentalist, to the illustrated catalogue that friends of Man Ray once prepared of his work. It was entitled simply *Good News*.

What are legitimate bases for the judgment of photographs? Since it is always easier to be negative, let me begin by suggesting some widely used but wrongheaded bases for judgment, ones we might profitably abandon.

The most popular one is *sincerity*. It is a topic dear to many adolescents because in the thrill of disillusionment they believe themselves to have made a revolutionary discovery — there are people who are frauds.

Among the fundamental problems in applying this accusation as photographic criticism is that it is, as literary

critics learned several generations ago, hard to prove. It is one thing to suspect a person of being false, and another to establish that he is; the photograph is there, the only relevant evidence (assuming there are no telltale letters or journals by the photographer), and it is difficult to show that it contradicts a photographer's inner beliefs. We may say that no sensible person would hold the beliefs shown in a picture, but that is another matter.

It is a truism, moreover, that we all act out of a mixture of motives. Most photographers themselves cannot say for sure why they photograph. This uncertainty is a legitimate prod to self-scrutiny, but not much of a basis for scorning others' suspected compromises. We all have to eat, and how we connect that need with the needs of the spirit is a matter none of us can afford to be especially self-righteous about.

To put "sincerity" in its place, let me suggest a thesis: sincerity is often in at least some senses a negative attribute in an artist, who by definition is looking for Form, for overall shape in life beyond the limits of immediate social or economic or political conditions. Some of the worst artists, after all, are the most sincere. Conversely, James Joyce could be accused of being an insincere Irishman; he does not really seem to care as much about Irish independence as he does about using the struggle for it to illustrate other truths. Walker Evans might be accused similarly of having not been sincere in his concern for the poor Southern farmers he photographed; doesn't he really use them as particularly defenseless stand-ins for all of us, and isn't that use rather cold and disingenuous?

The word *sincerity* then has with art to be subtly affixed, so that it refers eventually to what might be called the sincerity of the artist's detachment. When we discuss that, we are coming close to a legitimate critical focus, because with it we are concerned with the essence of art, the overall

configuration an artist finds in his material, the meaning he discovers in the seeming confusion of life.

Another improper standard of judgment is *biography*, the artist's life. It is not legitimate to dislike Marianne Moore's poetry because she wore crazy clothes or William Faulkner's novels because he drank too much, and it is not particularly germane to attack a photograph because the person who made it worked for *Life* magazine or a university, was or was not a socialist, did or did not like Minor White, and so on. The critic Max Kozloff suggested that an introductory book on a photographer ought to detail among other things "the artist's class origins" and "professional contacts." As a general rule, it should not, the reason being that the only things that distinguish the photographer from everybody else are his pictures; they alone are the basis for our special interest in him. If pictures cannot be understood without knowing details of the artist's private life, then that is a reason for faulting them; major art, by definition, can stand independent of its maker.

As the years pass I hope that critics will also drop as much of the heavy academic machinery as is consistent with getting at the truth. Elaborate ideational schemes for interpretation, such as psychoanalysis, tend generally to lead away from the photographs and in the process to oversimplify what is mysterious and of greatest value in the work. George Orwell wrote that "one can only 'interpret' a poem by reducing it to an allegory — which is like eating an apple for the seeds." I like that simile because there are so many wonderful pictures of apples (by Cézanne, Stieglitz, Steichen, etc.), and we don't want to forget to enjoy eating them. For some, however, ideas are the prime concern. Orwell illustrated the dangers of overinterpretation by quoting a passage from a book on *Hamlet*: "In ... *Hamlet*, an unconscious incest-wish incapacitates the hero for marriage with the girl he has

wooed." Orwell then observed in a line I like to quote to my intellectual friends, "Very ingenious, one feels, but how much better not to have said it!" How much better, he implies, would the play seem — how much richer, how much more complex, like life itself.

Suppose that we agree to stay away from sincerity, the details of a person's private life, and interpretive diagraming. What then?

To begin with, we ought to decide whether *any* public discussion of a particular work is appropriate. There are legitimate reasons for being hesitant to speak. Silence is after all the context for the deepest appreciation of art; the only important evaluations are finally personal, interior ones. And, even assuming that public discussion might be helpful, there are many ways to make it unhelpful; because photographs tend to be less inflected than paintings, there is, for example, the question of whether one has seen enough (Cartier-Bresson was right — anybody can take one or two good pictures, or, by extension, a lot of bad ones). To guide public taste fairly requires a great deal of preparation.

Let us suppose though that one has carefully determined that a body of work is bad, unambiguously bad. If so, is it not the critic's duty to speak up? Isn't there an obligation actively to clear away the second rate and the imitative? A critic's job is to support work of merit; how can good work thrive unless the other is conscientiously separated out?

Such questions are not answered quickly. John Rewald, in talking about Seurat and his imitators, identified the center of the problem: "While it is true that those who tried to *cash in* on the researches of Seurat and his group were so weak that they only underlined the strength and originality of the others, it is also true that public success, when it came at last, temporarily went to them, as it always goes to the

vulgarizers before reaching the initial inventors." The history of art is filled with people who did not live long enough to enjoy a sympathetic public, and their misery argues that criticism should try to speed justice.

On the other hand, there is the amply documented possibility that a critic's judgment may be wrong. One contemporary defender of the Impressionists asserted that no newspaper had ever discovered a new figure of talent; that is a hard thesis to refute even now. There is also a tactical consideration: in cases in which there is a defensible need for making, in public, a negative judgment, usually the most damaging negation is silence. It is a truism among publishers that a bad review no matter how bad is better than no review at all. True, their attitude is grounded in economics, but even looked at more seriously, a negative review usually implies at least that the issues raised by the work are important. No review implies the worst — boredom.

Maybe on occasion then we do not need to fear bad work as much as we had thought. Perhaps we can sometimes just let it do itself in. Conceivably we have been guilty of overkill, as were the judges of the French salon, who for some years stamped an "R" on the stretchers of rejected paintings.

If one's decision is, nonetheless, to write or speak critically, then one's first obligation is absolute clarity. Much criticism is apparently based on the mistaken notion that, because art is mysterious, criticism should be too. But criticism and art are not synonymous. Criticism's job is to clarify art's mystery without destroying it. Short of that it is a clumsy, intrusive embarrassment. When I read art journals I am often reminded negatively of an axiom by Robert Graves: "The writing of good English is a moral matter." The failure of many of the magazines is therein precisely described.

Often they are clotted with jargon, vague abstractions, tortured syntax — all evidence of the writers' concern with themselves. If there is a practical corrective, I sometimes think it might be for the writers to be forced to emulate the eighth-century Chinese poet Po Chii, who is said to have read his work to an elderly peasant woman and changed whatever phrasing puzzled her.

Assuming that the critic writes as lucidly as he can, what is the proper subject? Henry James proposed asking of art three modest and appropriate questions: What is the artist trying to do? Does he do it? Was it worth doing?

The first question can, admittedly, bog a person down in critical subtleties. How does one know an artist's intent, except in those rare cases in which there is a diary or other outside evidence? The only final proof of intent is in what has been called "achieved intent," the finished work itself; the rest, it can be argued, is irrelevant. What I think James had in mind is more a matter of common sense, however, or what one might wish were common sense. He just suggests that we start out by asking what it seems as if the goal had been. It sounds like elementary justice, but countless reviews are based on violating that justice.

After asking "What is the artist trying to do?" James's second question, "Does he do it?", is simple logic. To answer it, the critic must determine whether the work is internally coherent, whether the end sought is reached within the rules of operation established by the artist himself.

The last question (which cannot be asked, as some critics would, before the other two), "Was it worth doing?", is the most important. Many academics would like to avoid it entirely, but the rest of us won't let them. We insist, finally, that the critic make plain his own values. Mine, for example, when I try to measure whether something was worth doing, run to questions like these: Did it reveal Form, that is,

Beauty? Was it fresh; did it make old truths new? Was it a work of significant scope; did it reconcile important elements that had before seemed irreconcilable? All of which come, I suppose, to asking whether it helps us, in Samuel Johnson's phrase, to "better endure or enjoy life."

James's three questions outline the right methodology, but heaven knows they do not insure success. There are only a few people who seem able to write effectively at length about photographs. Among these few, John Szarkowski is so good that he may well be remembered as having been the equal or more of Stieglitz in his constructive influence on the medium. Szarkowski's writing has made him envied, but the irony is that his competitors seem to miss some of the most obvious keys to his success. Among these is that he writes only about what he likes. It is a practice that cuts down competition from the start; to be clear about how and why something works is difficult, whereas just to turn one's animosity loose on something weak is both fun and safe (who can accuse you of being sentimental?). No wonder the affirmative essays stand out, and, assuming they are about respectable work, last longer. Weak pictures drop away of their own weight, as does discussion of them, but the puzzle of stronger work remains; we are always grateful to the person who can help us see it better.

To put this another way, our best critics have the courage to take what seems the biggest risk: to forget themselves. Critical writing about a successful picture is a calculated and in some respects doomed redundancy, repeating in words what it means, duplicating it in other than the optimum mode, which, if the picture works, is obviously the visual mode. The only thing that can bring this off, assuming gifts of insight and expression, is the deepest commitment to share the picture with others. Anything less than that means defeat, calling attention not to the picture but to the critic.

I sometimes dream of an ideal photographic journal, perhaps distributed on microfiche so that we can all afford it. In my imagination it is assembled in somebody's garage in the Midwest. It is a magazine devoted to successful work, because that is all we have time for; it is a journal notable for its tact and lucidity, and it is full of pictures because they are the point. We might just take our cue from Man Ray's friends and call it *Good News*. And we won't allow ourselves to be labeled sentimentalists, because our title does not imply that good news in the short run comprises *the* news or even *most* of the news. In fact, we may note editorially that our attention to good news is evidence of our pessimism, our belief that good news is rare and that we cannot afford to overlook any of it.

I have two final thoughts, one for critics, the other for photographers. First, an observation as it was phrased by the director of the art department at Immaculate Heart College in Los Angeles: "All people in this world are made to *give evidence* or to signify something. Perhaps it can be said that as artists some are made only to show what surface light does to color. . . . Still others may be here only to reveal the possibilities of the color blue." In that spirit we ought as critics to remember that no subject matter is unimportant and no human response to it is unworthy of our attention.

The word of encouragement I would like to give to photographers is in the form of a statement by Matisse about painting, a statement we can apply by analogy to photography: "A painter has no real enemy but his own bad paintings." It is possible that, were I to look at your work, I would misunderstand or misjudge it, but my mistake would be of limited significance, assuming that your work is substantial and that you who made it see it clearly. A good picture powerfully vindicates itself in time; it is far stronger than a mistaken critic.

"A painter has no real enemy but his own bad paintings." That statement brings me back to the proper subject of criticism. In the highest sense, surely a photography critic's most important job is to help photographers of promise defeat their only real enemies, their own bad pictures.

THE LEARNING CENTRE
CITY & ISLINGTON COLLEGE
444 CAMDEN ROAD
LONDON N7 0SP
TEL: 020 7700 8642

PHOTOGRAPHING EVIL

ON THE D&RG Railroad south out of Walsenburg, Colorado, there stand the remains of a small coal-mining community named Ludlow — three abandoned shacks and a monument put up by the United Mine Workers. I drove eighty miles out of my way one morning in order to photograph the memorial — a statue of a man, woman, and child. The site is lonely, a nondescript place on dry flats; that day the wind blew, the sun was cold, and my equipment was unfamiliar. I found myself saying over and over again, please, just give me these pictures.

And I cursed myself for the foolishness of the effort. Lee Friedlander had done monuments better than I was ever going to. Moreover this one marked an atrocity — the killing of miners and their families by the Colorado militia — that happened too long ago, I suspected, for most people to care.

I knew nonetheless why I cared, and it had little to do directly with this place or with what others had done there. What weighed on me was what I had been doing in past weeks — photographing beautiful mines. I had contracted to picture extractive industries in Colorado, and in the process I had photographed pits cut by swirling roads as graceful as Robert Smithson's earthwork *Spiral Jetty* and rock faces

so powerful and serene they reminded me of classical build-
ings. I loved some of the pictures, but I also knew that I hated
the places themselves, and had been unable to record con-
vincingly what was wrong with them — the carcinogenic res-
idues that were being dumped into streams and air, for
instance, and the broken social patterns that the mines
brought to nearby towns.

What I wanted, and I knew it was hopeless, were pictures
of the monument that would somehow indict the new strip
mines to the north. But in most cases the miners there were
uninterested in a union and were, for all I had been able to
discover of their consciences, now themselves probably
members of the National Guard. I was left at the end of the
day with a sense of the certainty of evil, of the ambiguity of
what photography could do with it, and of the fact of my own
limited skills. After years with a camera I had wasted still
more time trying to do what it apparently was not given me
to do.

When I am discouraged now by the feeling that I do not often
meet my social responsibilities, I am not above trying to
cheer myself up by thinking about others' failures. Stieglitz
and Weston, after all, seem hardly to have known there were
poor people, and though Paul Strand was a socialist his
photography rarely shows it, just as currently most of
Chauncey Hare's photographs give little evidence of his
concern for economic reform.

When I recall, however, some of the specific photographs
these people have made — pictures like Strand's of the Mex-
ican woman with her basket of laundry (Plate XV) — I see at
once that this is not failure. The photographs are among
those to which we turn when lesser consolations fail. Their
strength is in fact identical to that afforded by successful
painting and sculpture. And with this realization I

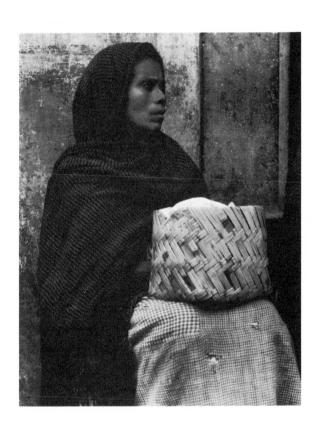

XV Paul Strand, *Woman, Pátzcuaro*, 1933

find some comfort. Photographers have generally been held to a different set of responsibilities than have painters and sculptors, chiefly because of the widespread supposition that photographers want to and can give us objective Truth; the word "documentary" has abetted the prejudice. But does a photographer really have less right to arrange life into a composition, into form, than a painter or sculptor? Bruce Davidson was criticized, for instance, when in East 100th Street he carefully posed some of his subjects. People did not look like that, it was argued, and we can only agree. The point of art has never been to make something synonymous with life, however, but to make something of reduced complexity that is nonetheless analogous to life and that can thereby clarify it. This is why we do not object to Goya's arranging into a pattern his figures in The Executions of May Third, or to Géricault's doing the same with those aboard the Raft of the Medusa. We accept these manipulations because they are the essence of art, the revelation of shape.

Citation of the foregoing works brings me, however, to pose a question that requires an admittedly subjective response, but an important question that I am convinced we all ask ourselves whether we admit it or not: are the greatest paintings and sculptures, generally speaking, those that deal directly with evil? Except for works in one category I believe they are not: the scenes at which I and a majority usually choose to look the longest and from which we derive the greatest strength are not Hieronymus Bosch's catalogues of sin, or Edvard Munch's studies of female predation, or Picasso's Guernica. Rather they are pictures that make no complaint or accusation, pictures by artists such as Hokusai, Degas, Cézanne, Matisse, and Hopper. It is a measure of our agreement on this that, though not everyone would share the fullness of my admiration for Hopper, few now would criticize him, as some of his contemporaries

did, for not directly addressing the problems of the Depression. Had he made those issues his first concern he would presumably not have given his attention as fully to a consolation that we sense was uniquely his to explore, the beauty of light on buildings.

There is, it is true, one kind of depiction that most people exempt from their resistance to art about evil — pictures and sculptures from Bible stories. Works by such artists as Gislebertus, Giotto, Masaccio, Ghiberti, Michelangelo, and Rembrandt are deeply and widely loved. But the events in these depictions carry with them a context that does not need to be retold visually, a framework of meaning that is understood to surround the scenes. The affirmation of life that these views make, and the triumph over evil that they imply, is based on more than what is literally shown or what could be directly inferred from what is shown. The pictures thus enjoy, insofar as belief in the stories is still alive, a unique position in current Western culture. It is a position that, for good reason, photographers have understood they could not appropriate for their own use.

All of which leads me to suspect that, with the foregoing exceptions, the static visual arts are not well suited to the direct exploration of evil. Various media can report on evil, but a single painting or sculpture or photograph rarely resolves our feelings about it into that balance of emotions toward which art has traditionally been understood to progress. On the evidence, the arts that do the best job with evil as their avowed subject are the narrative arts such as drama and fiction; good and evil are important to us finally as matters of choice, and to show the reality of choice requires that time pass, time for decisions to be made and paid for.

In periods of social crisis, photography as art can seem an inhuman escape. It is so often apparently distant from the

specific catastrophes in the day's news. Think of Stieglitz making, during the worst years of the Depression, his coldly beautiful views of New York City from the heights of the Shelton Hotel — or of Ansel Adams photographing in the Sierras as the worst of World War II was being fought in Europe.

In response to juxtapositions like these there are critics who have asked for "concerned photography," by which they mean photography that deals directly with social ills. Few photographers themselves have, however, supported the use of the adjective "concerned" as a way of distinguishing one artist from another; they know firsthand that all art is the product of concern. They believe as a consequence that it has social utility — it is designed to give us courage. Society is endangered to the extent that any of us loses faith in meaning, in consequence. Art that can convincingly speak through form for significance bears upon the problem of nihilism and is socially constructive. Restated, photography as art does address evil, but it does so broadly as it works to convince us of life's value; the darkness that art combats is the ultimate one, the conclusion that life is without worth and finally better off ended. Which is to say that art addresses an inner struggle whereas journalism more often reports on the outward consequences of it. Perhaps this is what William Carlos Williams meant when he wrote that "It is difficult/to get the news from poems/yet men die miserably every day/for lack/of what is found there." We have all had the sad opportunity to watch that. And though poems and pictures cannot by themselves save anyone — only people who care for each other face to face have a chance to do that — they can strengthen our resolve to agree to life.

To value photography as art is not however to denigrate photography in the service of different ends. We owe a debt to the cameramen who worked in Vietnam, for example.

Photographs like theirs encourage us to resist what evil it may be in our power to correct. Without honest reporters it would be easier to give up and to deny the complex imperatives of tragic politics — the necessity of trying to make the world better even while we learn that we will mostly fail.

Whether a person is led by concern to become an artist or journalist or reformer or a combination of the three must depend on the nature of his gifts and on the place and time in which he works. Who can identify the person we could do without? There have been occasions, for instance, when the threat to society has been so immediate and total that art has seemed to some artists irrelevant and thus impermissible; in consequence, as citizens of the world first and artists second, they have turned to making propaganda. I admire David Smith, for instance, for trying to speak out in the late 1930s with his production of the small bronzes called "Medals for Dishonor" (Plate XVI), even though it is impossible to locate a single event that he changed by them. The fact that he took time away from his regular work must have forced others to consider the source of his anguish; anyone who had admired what he had done before had to ask what was now more important.

Whatever a photographer's goals — reform of injustice or consolation for it — the chances are that his working experience will be in some degree like W. Eugene Smith's when he discovered as a combat photographer that he was looking at bodies first as elements in a composition. Like Smith we promise to ourselves never again to be so inhumane and manipulative. And like him we then discover that if we are to continue to make pictures we will continue to make patterns of disaster (this is true even for propagandists, since badly composed pictures are as ineffective as they are puzzling: on what is the viewer to focus his concern?).

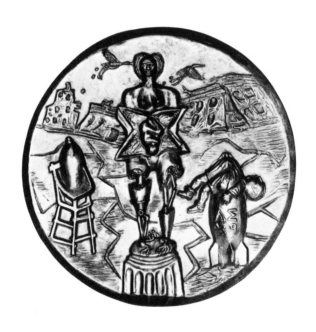

XVI David Smith *Medal for Dishonor No. 9 — Bombing Civilian Popula-
tions,* 1939 (plaster model for master bronze)

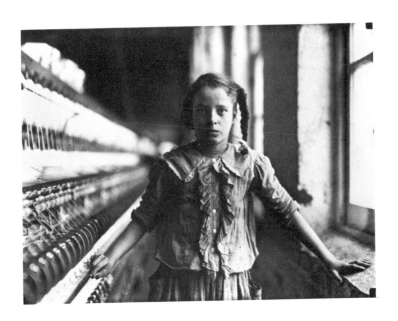

XVII Lewis Hine, *Spinner, Ten Years Old, Cotton Mill, North Carolina*, 1908

Caught in this tension, a few photographers have now and then been able to strike a perfect balance within single frames. Some of Lewis Hine's pictures are cases in point. Though Hine saw himself as a reformer and is generally regarded as one, he occasionally spoke of his vocation as being more complicated: he wanted to show, he said, both what was bad so we would oppose it and what was good so we would value it. Individual pictures of his accordingly can appear almost self-contradictory; the girls standing tired in front of spinning machines in textile mills are, for example, sometimes beautiful — as are the photographs of which they are a part (Plate XVII).

We feel an enormous gratitude for these paradoxical views — for the way they continue to help us, lifelong. When we are young, we want art that is filled with the bitter facts, because we believe that evil can be overcome if we face it; when we grow older and begin to doubt this optimistic belief, we want art that does not simply reinforce the pain of our disillusionment. In pictures like those by Hine the requirements of young and old are both met; the photographs urge reform, but seem to suggest that the need for it is not the most important thing to be said of life.

MAKING ART NEW

AMERICAN conversations frequently begin with the same question: "What's new?" It is a cheerful, almost liturgical affirmation of our common faith in the inventive spirit. Privately, a few of us may admit to doubts, but as a country we hold that Henry Ford was right when he said, "History is bunk."

In this context it is not surprising that art is not held in high regard. Though art must always be new, it is in profound ways never new. How different it is from an appliance, identifiable by model year, each year notable for its improvements. Indeed, as some have tried to sell art as if it were a constantly upgraded piece of technology, the public has had the good sense to suspect them of innocence or deception, and art's stock has fallen even lower.

Of course it is true that the apparent repetitiveness of art can be a comfort; there is solace in discovering that the filmmaker Eric Rohmer or the writer Flannery O'Connor is no more lost or found than was Aeschylus or Masaccio. Although as a practical matter we might wish that art made clear headway, and this tempts the artist to try to slip one over on us, to give us the look-alike for progress—novelty. A well-known Japanese photographer who has ironically im-

itated our American dislike of imitation is quoted as saying that "to me, if it's new, it is satisfactory"; he seems really to mean that if it is new it is good. It is the same claim that much contemporary art makes on our attention; we are asked to take it seriously because it is unlike anything we have seen before. A few years ago I was sent, as a delinquent subscriber to *Artforum*, a characteristic argument for prompt resubscription: "The pace of contemporary art is swift," the editors warned. Don't be left behind. All aboard for the art express, bound at dreamlike velocity for unknown lands.

We might be tempted to dismiss without comment a conception of art so unsophisticated were it not for the fact that the notion is popular and accounts for many difficulties. If we could clarify the ways in which art can and cannot be new, we could, for example, make it harder for those dealers who sell art like cars. We might additionally do a better job of interesting an audience in actually looking at pictures instead of reading about trends. Perhaps most important, we might enable young photographers to find their direction with less waste and pain. Currently, a great deal of energy is being invested in attempts to push photography into unusual areas; this is probably inevitable when a large number of beginning photographers try to distinguish themselves from one another and thereby win an audience, but it is also inevitable that each photographer's struggle is accompanied by a question: "Are the new pictures I have made true?" If that cannot be answered affirmatively, there is no peace to be found in the profession.

A Shakespeare professor of mine, William Main, who first discussed many of these issues with me, used to argue, despite his absurd membership in the Modern Language Association (an assembly of pedants and antiquarians), that there are really only two kinds of literature — modern literature and history. Sophocles, Dante, Shakespeare, and Joyce

are, he would assert, all modern literature. My thesis derives from his heresy; it is that the only thing that is new in art is the example; the message is, broadly speaking, the same — coherence, form, meaning. The example changes profitably, I think, because the span of our interest is fleeting, our imaginations are weak, and our historical perspectives are short; we respond best to affirmations that are achieved within the details of life today, specifics that we can, to our surprise and delight and satisfaction, recognize as our own.

The question "What is new?" implies a more hopeful question, "What is better?", and we can begin with that since it is easier to answer. What evidence can we marshal of progress? Presumably in art this would mean more Truth and/or Beauty. But we have to smile. At least I know of no serious author who claims to be preparing something more truthful than Henry James's novels, and I am unacquainted with any first-rate painters or photographers who believe that their pictures will be more beautiful than those of Rembrandt.

Nevertheless, a writer or painter or photographer may find his predecessor's understanding faulty, and may vow that he or she as a modern person will have to ditch the Oracle or Christianity or Marxism. The irony, though, is that a reaction against earlier sources of Form shows that a person is not free of them; only innocence would be freedom, and one cannot recapture that; as long as we respond to our forebears, they are with us. The main thing to be said, however, about specific theologies and philosophies as they are embedded in art is that, while their outline is important, their detail is not crucial to the greatness of the work, not even in as apparently doctrinaire works as those by Giotto or Dante. Theology and philosophy are not insignificant in art, because they provide a diagram for order, but it is notable

that over the centuries the diagrams change some while the fact of order remains. The classic proof that a work of art is major — that it outlasts its own age — suggests that the most important truths in it are less constraining than the codified world views of a particular time. If Shakespeare's greatness was that he was an Anglo-Catholic, then, as my professor used to point out, Shakespeare's plays would be as dead now as a collection of Elizabethan sermons.

With respect then to the most fundamental message in art, it appears that progress is questionable on the evidence of past work. Artists themselves have been quite open about this. Degas, generally regarded as an innovator, nonetheless argued that "art does not grow wider, it recapitulates." Cid Corman, a most unconventional contemporary American poet, writes that "the revolt of the poet is invariably conservative at its roots, no matter what faces are used or revealed. Not politically conservative, but imaginatively conservative, with a profound regard for what is given, as earth or air, sun or moon or stars, or the dreams of men." When one reflects a little, in fact, the notion of improvement in art is crazy. Fernand Léger may have been in love with modernity, but he knew exactly why: "The birds are *always* marvelously dressed, progress is a word stripped of its meaning, and a cow that nourishes the world will always go two miles an hour." That truth is one of the primary affirmations of art — how much art deals with cows, with (forgive me this one bad pun) stable nature.

It may be asked whether individuals and societies, as distinct from art in general, do not improve and thus sometimes improve their art. I am inclined to believe that within limits they can. The growth of a tradition of landscape art in the West is to me an instance of progress, a freeing up of our responses to important facts (though perhaps our heightened attention to landscape is no more than a reawakening

to what the Hebrew psalmists or Anglo-Saxon poets watched attentively a long while ago). But even beyond the general artistic growth that occasionally seems to occur within societies, surely there can be progress in an individual's efforts. I am encouraged, in my forties, by the number of people who make their best efforts on the far side of middle age, who in some cases might hardly be remembered were it not for work from their late forties onward. Ozu, Walker Percy, and Winslow Homer come immediately to mind.

If progress is questionable in art in general, even if not in a particular individual's art or a particular society's art, isn't it still obligatory that an artist's work be, in the context of art as a whole, at least fresh? Isn't it necessary for it to be, particularly in an age of art-book publishing, different from what has gone before?

Even this, on first reflection, seems a lot to ask. All art comes out of a background of convention established by one's predecessors. Every serious artist borrows not only from those conventions but from the particular insights of individuals he admires. This is unavoidable because, as the painter Mark Tobey observed, "No young artist can grow unless he emulates someone bigger than himself" — we all start small. Thus, Cézanne, for example, borrowed from Delacroix, and Matisse from Cézanne and Delacroix. It sometimes even seems as if the greatest artists borrow most. Certainly none of those just mentioned ever tried to hide his dependence on his sources; each, great as he was, understood that creations out of nothing are possible only for God. We seem in the end to be left with a series of revivals.

We rebel against that oversimplified conclusion, however. If art means just dusting off the old stuff, then our age with its obsessive nostalgia would be artistically richer than it is. I am depressed now, for example, by the sterility of

much photorealism in painting. And I am worried by the amount of time spent by photographers in trying to revive nineteenth-century photographic technology. There are conceivably interesting uses to be made of almost any photographic method, but so many contemporary enthusiasts for old ways seem to place their faith simply in the value of doing the antique thing once more. The results can be momentarily charming, but they are often finally sad, a footnote to history, arcane and a little saccharine.

No serious artist would, in short, ever set out simply to repeat another. If the history of art is made up of revivals, these revivals have to include a difference. The artist has to have a basis for claiming along with Matisse that "I have accepted influences but I think I have always known how to dominate them." That this need for independence is tied finally to the nature of art, and not necessarily to fashion or economics, is established by the experience of the artist, who commits himself to art precisely because he believes that he sees what others have not. If in the course of his training he discovers a master whose vision he wholly shares, then he becomes that person's advocate rather than an artist himself, and goes on perhaps to become a collector or teacher or professional critic. If however he finds that no one makes pictures like those he carries in his imagination, then he has to try to devise them. New pictures are the only way to avoid exile from himself. Should he fail, he is condemned to live by others' views, ones that must always seem inaccurate.

It is not just would-be artists who understand that art has to be reborn. We as an audience know it too, and waste little attention on the copier slaving away in front of the museum masterpiece. Though again, if the substance of art remains basically the same, why can't its expression remain so too?

Part of the answer is that the simple perceptual pleasure

that art offers depends to a degree on freshness. Even the most extraordinary canvas by Matisse loses some of its power over the years. The depletion is certainly not a matter of familiarity breeding contempt — it is just a gradual slackening. We apparently need what some would call a childish delight — the fun of surprise.

Usually the artist who makes something fresh also helps us by minimizing the differences of time and place and attitude that inevitably distance us from earlier generations. Shakespeare's plays may be modern literature, but when someone else can demonstrate the same truths out at the edge of the interstate our response is bound to be stronger. The texture of the world is an important part of art's subject, and aspects of that texture do change.

Finally, there is a related and more important reason for needing newly contrived art: all man-made things die away, and art is just one more of our vulnerable contraptions. It is an invention of symbols, a culling out and intuitive reassembly of items from daily life, arranged so that they will point beyond themselves. Serious photography, no matter how "straight" or apparently objective, is this sort of invention, and, like everything else we devise, it can be depended upon to quit working. Eventually the symbols so outlast their original context that they no longer effectively point anywhere, becoming instead only artifacts for the documentation of cultural history.

We welcome contemporary art, then, for its power to please the eye, to record the texture of current experience, and to invest that experience with meaning.

In response to the question "What's new?" we can answer with conviction that photography is new. We can make this claim not because it was invented rather recently, and not primarily because of photography's changing technology

(there are forms of art with more advanced hardware), but because photography is by its nature forced toward doing the *old* job of art — of discovering and revealing meaning from within the confusing detail of life. The freshness of photography can be felt, paradoxically, when one reflects that Nick Nixon's pictures have more in common with those of Piero della Francesca than those of Franz Kline, Robert Frank's pictures with Brueghel's than with Robert Motherwell's, Mark Cohen's with Goya's than Frank Stella's, and so on. One reason for this is obvious — the photographs had to be built from life, directly. Photography is new, I submit, because it is among the few arts that have, through the twentieth century, remained attentive to the facts of this world, to the actual appearance of the place that troubles us. In painting and sculpture it has been lethally easy to escape right off into some alleged spiritual essence, or to lounge flabbily around as ornament.

It is this great restriction upon photography — that it can go nowhere without first paying worshipful attention to the concrete — that makes me know that photographers do not need to worry. Photography can always be new, because the surface of life keeps changing. Yes, photography like all the arts will go in seasons, but it is not a fad anymore than is life itself.

The only melancholy note that has to be appended to this observation is one Dorothea Lange made a long time ago: "Photography today appears to be in a state of flight The familiar is made strange, the unfamiliar grotesque. The amateur forces his Sundays into a series of unnatural poses." It is a difficulty that is common to all the arts, but it is perhaps especially noticeable in photography, where the camera's record of the subject is so detailed that it makes contrivance seem particularly hopeless.

When I have occasionally spoken with photography stu-

dents, I have sometimes quoted another remark of Dorothea Lange's, one she made shortly before she died, as a lament: "Oh I can think of things we don't photograph," she said, "things we *could* photograph, and we never touch them." I have asked students, at the beginning of their careers, what things of that sort might haunt them — what things they *must* photograph, things they have to try to shoot even before they master the intricacies of making dye transfers. It saddens me that I am rarely answered. Where we might expect from the young an admirably ambitious goal, there is instead silence; I feel like telling them what Robert Henri told his students: "It takes a tremendous amount of courage to be young." I wish I could convince them that none of us want them, in their twenties, to be old.

Not long ago, at a university press where I occasionally work, I came upon an advertisement from a self-described photojournalist. I respect the man's catalogue of "photographs available"; there were maybe seventy-five categories, and what a jolting, hell-for-leather list it was: barbers; cheerleaders; civil war pageants; clowns; fishing; flowers; food; Galena, Illinois; picnics; sunrises and sunsets; trucks. . . . I know that photojournalism is not necessarily art, but without some of that man's spirit art is itself not very likely.

Why are important areas of life getting past us? Why, for example, do we have so few pictures of family life in America? Where are our pictures of the actual experience of working in industry? And where, despite all the photography students, are our pictures of what it is like to be a student in a large university? The only thing that denies us these pictures is a lack of commitment to go out and get them — to be absurd, to fail to earn a living, to be unable to explain, to endure our friends' pity . . . to do it. "Most expressive discoveries are made in old familiar subject matter," the art

historian A. Hyatt Mayor wrote. "The really original artist does not try to find a substitute for boy meets girl, but creates the illusion that no boy ever met a girl before." Photography is by nature on intimate terms with old familiar subject matter; all that remains now is for us to create new illusions in the service of truth.

Antagonists call attention to an apparent limitation that I have not thus far considered. It is this: even if the constant change in the surface of life insures that photography cannot be repetitious as long as its practitioners are courageous, isn't it true that there is, owing to the nature of the camera, a perennial style — what is known as "straight photography" — and that this style is finally monotonous?

The first thing to be remembered is that all art, even Wagnerian efforts like motion pictures, operates within limits, and that attempts to push back those limits, attempts typical of our naïve age, have not proved very liberating or durable. Most paintings of the first rank are still two dimensional, most sculptures are still without sound, and most novels remain unillustrated. What this suggests to me is that the limits of an art may contribute to its strength and that they are not to be regretted as much as used.

With respect to photography's limits and whether photography has a perennial style, I think that in some measure it has. Judging by a century and a half of evidence, there is a prevailing approach that is characterized by direct vision. Now and then I myself weary of that vision: photography is a cold medium; it can be expressive, but relatively less so than other kinds of graphics, and I occasionally enjoy more the warmth of pencil lines or brush strokes.

At the same time it is also self-evident that there are important variants possible within photography's perennial style; there are new things that happen in the ways photog-

raphers enunciate old truths. The acceptance and use of radical cropping, for example, is an obvious point of continuing development in photography (not unnoticed by painters). The serious use of color is another, as is the more and more subtle use of flash. Actually, every successful photographer changes the mechanism of approach a little.

Central to any consideration of this issue is, however, the fact that style is never, in important art, important by itself. It cannot even be understood by itself (which is the reason for the Pirandello-like confusion over the meaning of some contemporary, essentially decorative painting). Thus, though the stylistic paths open in photography are, compared to painting, in certain ways restricted, the chance that photography can in practice be fresh is wonderfully enlarged by the ways that a particular photographic method of attack can be matched to the wide variety of potential subjects open to the camera, a variety much greater than is easily open to painting. As subject matter changes and is mixed with a variant of the perennial style, photography can always be significantly new; a particular photographic approach, insofar as we can speak of that style as visible by itself, can carry with it the power of a radical departure. Diane Arbus's photographs, which are stylistically traditional, are an example of this power by compound. Or, to take related instances, we might ask how it is that we are often able to determine the authorship of photographs by André Kertész and Lee Friedlander. It is not that either man is identifiable because of his subject, or because of his manner of approach to it; it is because of the match. What seems to have happened is that small technical variations — format, speed, etc. — opened to them by the Leica were combined, under the pressure of their intuitive vision, with new concerns from life, specifically a new attention to aspects of

urban street life. The result of this amalgamation is something we recognize as fresh, as theirs alone.

What is new in art? Man Ray, who liked to make puzzles out of solutions, once observed that "there is no progress in art, any more than there is in making love." Robert Frost knew how to answer that one, however: "Poetry is like love," he said. "It begins in delight and ends in wisdom."

There is a difficult progress that is open to all of us, and photographers have an opportunity to participate in it and contribute to it. In these discouraging hours of our society's apparent decay there has never been more need for those who can, by whatever means, seriously recount for each of us what is new. T. S. Eliot, that radical traditionalist, described the nature of the struggle in "East Coker":

> . . . Each venture
> Is a new beginning . . .
> . . . what there is to conquer
> By strength and submission, has already been discovered
> Once or twice, or several times, by men whom one cannot hope
> To emulate — but there is no competition —
> There is only the fight to recover what has been lost
> And found and lost again and again. . . .

RECONCILIATIONS WITH GEOGRAPHY

Minor White
Frank Gohlke
C. A. Hickman

Minor White

MINOR WHITE believed that photography was a way to know, and might even have agreed with Henry Miller, who said that art would die away when we all had learned enough. White's fundamental conviction that good photographs have to match up accurately with life is incontrovertible. We need only cite as evidence the fact that nobody can talk someone else into liking a picture. That just happens, suddenly one morning or slowly over a season, when a picture or the recollection of it aligns with the person's experience.

That in any case is how I came to value certain of White's landscapes. I lived on the Oregon coast next to a spectacular, often fog-shrouded headland; on clear days I could see from its summit across fields of salal, down hundreds of feet of rock, and finally out over the ocean. It was like parts of the Bay Area coast, and I began to understand, far from museums and art magazines, just how reverently White had paid attention to what he saw in California.

It was White's gift to understand passionately the limits of documentary photography narrowly defined. "The objectivity of the camera, used wrongly," he observed, "is the very devil." He knew that great pictures cannot be just about

particular landscapes; they have to direct us to more, even eventually to the whole of life. If they do not, then "the documentary photograph, the literal image, is the ultimate illusion."

White's choice of the ocean as a subject was for him exactly right. Its appearance, closely observed, is hypnotic; who can be uninterested in so delicate a light, or the power of waves on rock, or the immensity of the whole view? White's pictures come to more, however, than just these geographic facts, as anyone who has walked the beach almost knows they must. The ocean, by virtue of its size and apparent emptiness, invites attention outward from our petty landscapes, away from ourselves (White said once that he was "appalled by the image of his inner landscape"). The sea is too vast to understand and too awesome to avoid; it attracts us as it offers a final liberation from human scale. All this coincided richly with White's understanding of art as metaphor, as a suggestion of similarities between the known and the barely known.

If it was White's achievement to show us that photographs can point beyond themselves, it was his fate as a human being, limited like the rest of us, sometimes to fail. But, because his goals were major, the failures are not entirely failures; they have value as they are instructive. White, who was a fully committed teacher, would surely have told us to use whichever of his pictures might help.

One can begin by noting that White himself sensed a potential problem in what he wanted to do. He observed hopefully, referring to some of his own work, that "the spring-tight line between reality and photograph has been stretched relentlessly, but it has not been broken. These abstractions of nature have not left the world of appearances; for to do so is to break the camera's strongest point — its authenticity." At his best, White made pictures

that were strong because of that authenticity, the appearance of the world. When he failed, it was because he tried to escape it, to travel to what e. e. cummings sardonically called a "hell of a good universe next door." Because we all have wanted to make that trip, in sheer weariness with home, we can sympathize, but, because there is no hope of reaching such a destination short of death, we are obliged to resist it.

The problem of an art in flight from the world of appearances was not uniquely White's. I would trade all of Stieglitz's pictures of blurry night clouds for one of his sharply focused views of the sky in daylight, one of those in which he customarily nicked in some solidifying foliage from the ground where we walk. The same issue, in slightly different form, has always plagued fiction; writers struggle against the temptation to write allegory, airy stuff where characters walk stiffly around wearing signs, instead of slouching ambiguously past like our neighbors, and only afterward coming to represent more than just themselves. It is the strength of art over allegory that it is more like life; in art as in life, abstractions and truths of the spirit reach us only as they are embodied in believable specifics, in recognizable particulars, what William Carlos Williams identified succinctly as "things."

For things to be credible in photographs requires, I think, that there be an indication of the subject's actual size. White, however, turned away from literal geography when he made landscapes that omit an indication of scale. The pictures range from what I presume might be medium shots to close-ups, but the practice in all of them is so thoroughly to deny the viewer clues to size that the difference does not matter. We cannot grasp with certainty whether the literal geography is composed of sand or gravel, whether a view is an aerial or an examination of disintegrating plaster (Plate XVIII).

XVIII Minor White, *Wall, Santa Fe, New Mexico,* 1966

XIX Minor White, *Pacific, Devil's Slide*, 1947

Why did White do this? I sense, when the practice is considered together with the narrow range of his subject matter, a struggle with the world of appearances that must have at times been extreme, and from which escape must have been attractive. I can also appreciate that the formulation of landscapes without scale might have seemed to him an appropriate pedagogical tactic for leading students to look at life, however ironically counterproductive it seems to me. If the whole of creation can be found in its smallest fragment, why not try to suggest this by withholding indications of scale? In fact, why not try positively to upset our preconceptions about size, as he did in some of the pictures he made in Utah, in which he radically combined what was close and far.

The erasure of identifiable scale is augmented by other practices that discourage viewers from knowing what the literal subjects of the pictures are. Even in the sequence of coastal pictures, "Song without Words" (Plate XIX), White chose to upend one of the seascapes so that we are compelled to perceive it first as pure shape. His relegation of captions to the end of *mirrors messages manifestations*, a large book, effectively forces us to encounter many of the pictures as abstractions. (One of the captions — "Bullet Holes, Capitol Reef, Utah" — transforms a rich but puzzling photograph into a great one. With the caption we see at once two subjects, the damage by gunfire, and a constellation of stars; in what other picture is our disgust arrested so sharply by wonder?)

White did make beautiful landscapes that are nearly unidentifiable. They are, though, never wholly cut away from the recognizable world. I think particularly of the calligraphic reflection in water above a dam, and of the bird-shaped shadow on a white canyon wall. In these photographs the setting requires a moment's study to identify, but

it can be done. And once done, we can look again at the calligraphy or bird and feel the astonishment that White intended us to feel; how extraordinary the commonplace world can be — miracles can come from it. But again, the context is essential; miracles alone, without the norm, are not really miracles at all. Without the setting of the identifiable world we are unconvinced of White's transcendental truths because we are not allowed to experience the conditions of their discovery.

The question of how close a photograph ought to stick to the outward appearance of life, even when describing miracles, is not necessarily best answered by the literal minded. Aristotle argued that it was legitimate for playwrights to include probable improbabilities, things that were unbelievable except within a playwright's imaginary world onstage, provided that the overall production revealed truths about life as we experience it offstage. The general success of White's infrared landscapes can be understood on these grounds.

My favorite of White's infrared pictures is the one of poplars along a road near Dansville, New York. In the brilliant leaves there is a discovery: many trees, though they are in fact usually dark, appear to be full of light, perhaps because the leaves, especially poplar leaves and especially in the wind, reflect it. In any case, when I look at the picture I think of Williams's beautiful line, "there is a bird in the poplars — it is the sun!" White's metaphor is simpler — there is light *in* the poplars, it is the sun — but it is a likeness that is in its visual expression just as lovely.

I have said that certain of White's landscapes seem to me unsuccessful because they fail to convey a clear indication of scale and are thus not identifiably of the world we know. It can be argued that in this I am simply rejecting the Roman-

tic vision and that it is unprofitable to dispute matters of belief. This is probably true, but it seems necessary to try to contest the point because the abstractions come to a closed landscape where, lost in our private dreams, we can no longer communicate. Sooner or later we have to ask of all pictures what kind of life they promote, and some of these views suggest to me a frightening alienation from the world of appearances.

The beauty of the seascapes offers an alternative. White's goal with them was presumably the same — to convey a sense of the mysterious, limitless nature of the Creation — but they, unlike the abstractions, also convey peace. It is a calm defined through metaphor: oceanic scale is the scale of eternity. Such a testament is itself baffling, but we are encouraged to try to understand it by its provision of a place to begin. We can, as White did, walk the shore.

Frank Gohlke

THE TORNADO that crossed Wichita Falls, Texas, on April 10, 1979, destroyed twenty-six hundred homes, damaged twice that many more, injured three thousand people, and killed forty-six.

Frank Gohlke, who was then teaching in Colorado Springs, managed to reach Wichita Falls three days later, and had only a Saturday and part of Sunday to photograph. At the end of his work, though he calls himself an apostate, he went to church; he speaks, still in wonder, of the beauty of the old hymns. One is reminded that, though the pictures show a public tragedy, they result from a lifetime of individual experience — Gohlke had grown up close to the stricken neighborhoods, and members of his family who still lived in Wichita Falls had been in danger. An idea of the intensity of his personal response can be sensed from the fact that his record was achieved with only forty-three sheets of film, all he had. If Ansel Adams is right that a photographer does well to get a dozen first-quality shots a year, then Gohlke lived better than a year in a day and a half.

The pictures are significant ultimately because they are about more than the news or one photographer's private response to it. Many who went through the storm remarked

that it seemed to them like a war; there had been warning sirens, abrupt destruction accompanied by terrifying noise, and eventually soldiers, roadblocks, and crowded hospitals. The war the photographs suggest, however, is one we can so far only imagine; unmistakably the remnants are of modern suburban America, a landscape immune from any but nuclear attack.

Newspaper photographs carried this same frightening prophecy, though Gohlke's pictures are not as a group likely to be confused with them. What the wire photos showed was wreckage, simple and absolute, whereas Gohlke's pictures, although they too make clear the devastation, show order. His composition implies a belief in the endurance of shape; the pictures are metaphor, an assertion of meaning within the apocalypse.

True, Gohlke would, like most photographers, not want to talk about his beliefs (he shows them). He speaks immediately about not having wanted to falsify with any philosophy the truth of specific facts, and explains that he was committed to this in part because he felt guilty about taking pictures while others worked to repair basic necessities. But he would not, moral man that he is, have been able to keep at it if he had not realized that his pictures of the destruction would be, as much as carpentry or masonry, themselves acts of reconstruction. It is his vision of form that is his chief gift to his old neighbors, and to survivors generally.

Gohlke's well-ordered photographs are convincing because they show an analogous structure in nature itself. Life validates art. The trees particularly are prime evidence ("Why do all photographers have to photograph bushes?" Alfred Barr once asked Nancy Newhall): with them Gohlke shows what can and cannot happen. The storm ranked 4 on the international Fujita scale, a magnitude documented by the wind's scouring of bark from trees. But what resilient

XX Frank Gohlke, *Bent Pole*, 1979

wrecks these trees are; in the photographs many still exhibit their basic, upright symmetry, and will be green again before the summer is out. Gohlke feels toward them as do his fellow townspeople, who plan to memorialize their dead by planting a grove.

What remains of our technology is of course itself eloquent too. Boards lie patterned across fields, wrack on a peaceful ocean. A light pole stands bent to the force of the wind, tracing the configuration of the unseen (Plate XX).

C. A. Hickman

MORE PEOPLE currently know the appearance of Yosemite Valley and the Grand Canyon from having looked at photographic books than from having been to the places themselves; conservation publishing has defined for most of us the outstanding features of the American wilderness. Unfortunately, by perhaps an inevitable extension, the same spectacular pictures have also been widely accepted as a definition of nature, and the implication has been circulated that what is not wild is not natural. This restrictive interpretation is unintended and demoralizing — a reading that conservationists must now work to correct if their efforts are not to prove counterproductive. Nature photographers particularly need to widen their subject matter if they are to help us find again the affection for life that is the only sure motive for continuing the struggle toward a decent environment.

Consider as a positive example of generous vision the accompanying panoramas of early twentieth-century life on the South Dakota prairie. Views like these remind us of the beauty of the plains — the shapes of trees against the sky, the roll of the land, the richness of grain. If the function of nature photography is to show us nature's loveliness, then

these pictures are successful models of the genre. (A few may object that the photographs are unequally exposed and not everywhere in sharp focus, but to argue technical niceties is beside the point here.)

An obvious question, nonetheless, is whether the pictures, which prominently depict people and what people make, can be seen as inspiring nature pictures. After all, the soil has been broken, the hills are tracked with roads, and cheap buildings have been constructed.

Contrary to popular expectations, many of the best nature pictures — often the truest and finally most reassuring — do contain people and their works. The strength they add to these photographs from the early 1900s, for instance, is fundamental. By depicting human beings, the pictures forcefully record the scale of nature — something we fully understand only when we measure Creation by the size of our bodies and the things they can affect. To see a family in the middle of the prairie allows us to know that the land is a finality, that it will be there longer than human beings or anything they fabricate. In this way, the pictures contribute to wisdom, which in turn gives us a basis for calm.

Here, I am not questioning the value of photographs by Ansel Adams (two of whose prints hang in my home) or Eliot Porter. Their pictures of uninhabited nature are important exactly because they reveal the absolute purity of wilderness, a purity we need to know. Attention only to perfection, however, invites eventually for urban viewers — which means most of us — a crippling disgust; our world is in most places far from clean. Photographs that suggest an Arcadian landscape are recognizable from the city dweller's perspective as partial visions, and they make us uneasy. We feel our defenselessness against what we will encounter on the street. How can trees in Sequoia National Park save us from the concrete-and-glass brutalities of New York City? The

answer is, in simple emotional terms at least, that they cannot; to be reminded of the trees makes city streets seem worse.

The extensive publishing of wilderness photographs by conservation organizations began in the mid-1950s, at the time of the struggle to save the canyons in Dinosaur National Monument. I recall the desperation of those who hoped to rescue that wilderness from the Bureau of Reclamation; the first summer my father and I ran the rivers there, in 1953, we were reportedly among fewer than two hundred people that season to do so. How were enough people to be informed of what they were about to lose? Photographs — the more extraordinary the better, because the place itself is so remarkable — were the logical answer.

There are now far fewer unpublicized wilderness areas, and there are relatively few converts, with the exception of children, left to be won to the general idea of wilderness preservation. We have fairly well sorted ourselves out into developers, strict preservationists, and those willing if not pleased to accept a compromise. This leaves photography with a new but not less important job: to reconcile us to half wilderness, to what Walker Percy described in his novel *The Moviegoer* as our common "estate," an inheritance reminiscent of "the pictures in detective magazines of the scene where a crime was committed; a bushy back lot."

Photographers who can teach us to love even vacant lots will do so out of the same sense of wholeness that has inspired the wilderness photographers of the past twenty-five years (the deepest joy possible in wilderness is, most would agree, the mysterious realization of our alliance with it). Beauty, Coleridge wrote, is based in "the unity of the manifold, the coalescence of the diverse." In this large sense, beautiful photographs of contemporary America will lead us out into daily life by giving us a new understanding

XXI-XXIII C. A. Hickman, *South Dakota*, ca. 1890

of and tolerance for what previously seemed only anarchic and threatening.

Walker Percy's description of our estate refers, admittedly, to "the scene where a crime was committed," and he is right to suggest thereby that some vacant lots demand, on our part, a judgment before we can accept the ease of a reconciliation with them. This renders the photographer's experience uncomfortable. I remember discovering, one morning while I was photographing along a Denver freeway, a deer's leg under a guardrail; apparently, a hunter had roped his kill to his car and the leg had been broken away in traffic. The smog, the mangled flesh, and the noise of eight lanes of jammed traffic were terrible, and the picture I took — the last I could bring myself to make that day — was full of the disgust I felt.

I continue to wonder about the wisdom of muckraking; ultimately, all photographs are of nature, a subject only ambiguously ours to judge. Given the facts of where most of us are compelled to live, did I help more by condemning what I saw in that scene than I would have had I tried harder to discover a truth beyond the need for reform?

Nature photography of even less extreme scenes, but photography that acknowledges what is wrong, is admittedly in some respects hard to bear — it has to encompass our mistakes. Yet in the long run, it is important; in order to endure our age of apocalypse, we have to be reconciled not only to avalanche and earthquake and hurricane, but to ourselves.

C. A. Hickman, the amateur photographer who made these views in about 1890 (Plates XXI-XXIII), was forthright; he included elements that were by common photographic standards imperfect — a broken-down hay wagon, a quantity of weeds, a woman who shades her face into confusing obscurity. Hickman's inclusiveness pays off, however, with

pictures of significance that help us, a long way from Eden, to endure and even enjoy life. The people stand there virtually in the way; yet, at the same time, they establish the vast dimensions of the pictures and thus reassure us that they and we are not all-important — certainly not powerful enough to cause anyone to despair.

We end with a paradox: in some nature pictures, it is precisely the troublesome, intrusive people who disclose nature's best truths.

These particular pictures are, of course, doubly enjoyable because the people themselves, however disruptive, are likable; they understand what the pictures are about. We can see by the places they choose to pose and the way they situate themselves that they know their size and affirm it. They are content to be remembered feeding the chickens, not the sort of activity recorded by turn-of-the-century captains of technology.

Of all the people in the pictures, it is Hickman himself, who got his shadow in by mistake, that impresses me most. To sweep the lens of a panoramic camera over so much is to rival Whitman. Awe must have induced the photographer to trust in the ultimate beauty of the whole landscape, primordial and man-made; how else would the pictures have been possible, except in the realization that no subject is finally unworthy, unnatural, or unsafe?

THE LEARNING CENTRE
CITY & ISLINGTON COLLEGE
444 CAMDEN ROAD
LONDON N7 0SP
TEL: 020 7700 8642

Acknowledgments

The author and Aperture, Inc. are grateful to those who have provided illustrations for *Beauty in Photography*: Cole Weston (I); Daitoku-ji Collection, Kyoto, Japan (II); Dorothy Norman, as published in *Alfred Stieglitz, An American Seer* by Dorothy Norman, Aperture, 1973 (III); Daido Moriyama (IV); Magnum Photos, Inc., New York (V); Jacob A. Riis Collection, Museum of the City of New York (VI); Doon Arbus (VII); Dallas Museum of Fine Arts, The Eugene and Margaret McDermot Fund (VIII); Nicholas Nixon (IX); The Pierpont Morgan Library, New York (X); Library of Congress, Washington, D.C. (XI, XIII); Dorothea Lange Collection, The Oakland Museum (XII); International Museum of Photography at George Eastman House, Rochester, New York (XIV, XVII); The Paul Strand Foundation, New York, as published in *Paul Strand: A Retrospective Monograph, The Years 1915–1968*, copyright 1940, 1967, 1971, Aperture, 1971 (XV); David Smith Papers on deposit to the Archives of American Art, the Smithsonian Institution, Washington, D.C., by the David Smith Estate (XVI); The Minor White Archives, Princeton University, copyright The Trustees of Princeton University (XVIII, XIX); Frank Gohlke (XX). Plates XXI–XXIII are from the collection of the author.

Grateful acknowledgment is made to the following publishers for their permission to reprint material under copyright: Alfred A. Knopf, Inc., and Faber and Faber Ltd. for "August 24, 1961" from *Markings* by Dag Hammarskjöld, translated by Leif Sjoberg and W. H. Auden, copyright © 1964 by Alfred A. Knopf, Inc., and Faber and Faber, Ltd. (page 19); New Directions Publishing for "Asphodel, That Greeny Flower" from *Pictures from Brueghel and Other Poems* by William Carlos Williams, copyright © 1955 by William Carlos Williams (page 70); Harcourt Brace Jovanovich, Inc., for "East Coker" from *Four Quartets* by T. S. Eliot, copyright © 1943 by T. S. Eliot, renewed 1971 by Esme Valerie Eliot (page 88).

Copyright © 1996 Robert Adams. All rights reserved under International and Pan-American Copyright Conventions. No part of this book may be reproduced in any form whatsoever without written permission from the publisher.

The cover photograph was made by Eugene Buechel, S.J., in 1932. It appeared originally in the exhibition catalog Eugene Buechel, S.J.: Rosebud and Pine Ridge Photographs, 1922–1942 (Grossmont College, 1974), and is reproduced here through the kindness of David Wing.

Library of Congress Control Number: 88-82874
Paperback ISBN: 0-89381-368-0
Design by Charles Mikolaycak
Printed and bound by Quinn-Woodbine Inc., Woodbine, New Jersey

A John Simon Guggenheim Memorial Foundation grant supported final stages of manuscript preparation; a grant from the National Endowment for the Arts provided partial funding for the publication. "Civilizing Criticism" was first published by the Friends of Photography, Carmel, California, as "Good News" in Untitled 14; "C.A. Hickman" appeared as "Inhabited Nature" in Aperture 81.

The purpose of Aperture Foundation, a not-for-profit organization, is to advance photography in all its forms and to foster the exchange of ideas among audiences worldwide.

Aperture Foundation,
including Book Center and Burden Gallery:
20 East 23rd Street, New York, New York 10010.
Phone: (212) 505-5555, ext. 300. Fax: (212) 979-7759.
E-mail: info@aperture.org

Aperture Foundation books are distributed outside North America by:
Thames & Hudson Distributors, Ltd.
44 Clockhouse Road
Farnborough
Hampshire, GU14 7QZ
United Kingdom
Phone: 44 (0) 1252 541602
Fax: 44 (0) 1252 377380
Web: www.thamesandhudson.co.uk

To subscribe to Aperture magazine write Aperture, P.O. Box 3000, Denville, New Jersey 07834, or call toll-free: (866) 457-4603. One year: $40.00. Two years: $66.00. International subscriptions: (973) 627-2427. Add $20.00 per year.

Visit Aperture Foundation's website: www.aperture.org

Second Edition
10 9 8 7 6 5